THE CARE

OF

BRONZE

SCULPTURE

THE CARE
OF
BRONZE
SCULPTURE

Recommended Maintenance Programs
For the Collector

by
PATRICK V. KIPPER

∴ *Path Publications*

Second Edition August 1998

Printed in the United States of America

The Care of Bronze Sculpture is published by Path
Publications in conjunction with Rodgers & Nelsen
Publishing Company. Inquiries should be directed to:
> Rodgers & Nelsen Publishing Co.
> P.O. Box 7001
> Loveland CO 80537-0001 U.S.A.
> (970) 593-9557

Production Credits

Cover Photography: NLS Photography

Editing: Nancy Schmachtenberger & Barbara Teel

Design & Electronic Prepress:
> Ben Teel
> Teel & Co.
> Loveland CO

Project Coordination and Printing:
> Craig Nelsen
> Rodgers & Nelsen Publishing Co.

Important–Please Note!

This book was written for the collector of NEWER sculpture that has been cast and/or fabricated in bronze. Step by step instructions have been given in order to guide the collector through the various steps of maintaining bronze surfaces and their patinas (colorations) for indoor as well as outdoor environments, in order that these surfaces and their existing patinas may be protected and enjoyed for many years.

This book is NOT intended as a guide for maintenance of antique bronze sculpture nor those of antiquity. A qualified and experienced conservationist who specializes in the area of bronze artwork should always be consulted prior to any maintenance on such bronze castings. Attempts at cleaning and waxing bronzes of antiquity may not only disturb their aging beauty, but also may considerably decrease the value of these bronzes.

Although sculpture cast and/or fabricated in bronze alloys may last for centuries, their delicate patinas as well as their sometimes fragile surface finishes may be disturbed by foreign contaminates introduced from the bronze's immediate atmosphere. This contamination, in many cases, will tend to destroy an exquisite patina coloration and continue to "pock" or eat away at the bronze itself. To avoid or slow this degenerating process, regular cleaning and rewaxing may be necessary. Not only will this maintenance of newer bronze castings protect their surfaces, it will also enable the collector of these bronzes to enjoy their beautiful surfaces for many years to come.

Dedicated
to the collectors
of fine bronze sculpture
in appreciation of their love and support
for this three-dimensional art

About the Author

Patrick V. Kipper is nationally known and respected for his knowledge of the care of bronze sculpture. He has 20 years of experience as one of the nation's leading artisans of bronze patination, as well as 12 years of experience in the field of bronze conservation and restoration.

A master patineur, Mr. Kipper has personal experience in the sealing of patinas on bronze statuary for its protection from both indoor and outdoor environmental contaminants. As a conservationist, Patrick understands the deterioration process of the patinaed surface of bronze as well as of the bronze itself, if left unprotected for an extended period of time.

Mr. Kipper presently lectures on the art of patination and bronze protection at major schools of art, in the academic and private sectors. He maintains a studio in Loveland, Colorado, for the patination, conservation, and restoration of bronze and is a member of the American Institute for Conservation of Historic and Artistic Works.

Acknowledgments

The author would like to thank the following individuals and groups for their participation in making this book possible:

Sculptors	Glenna Goodacre
	Steve Kestrel
	Phillip McTaggart (deceased)
	Valentin Okorokov
	Sherry Salari Sander
	Sandy Scott
Photography	Bill Carpenter
	Jane Hill
	David O. Marlow
	NLS Photography
	Mel Schockner
	Nicolas F. Veloz

Loveland High Plains Arts Council

Loveland Visual Arts Commission

Conservationist Nicolas F. Veloz

American Institute for Conservation of Historic
 and Artistic Works

Rodgers & Nelsen Publishing Company

Corporations CHEMIFAX
 SC JOHNSON WAX
 KIWI BRANDS, Division of Sara Lee

Contents

Preface

Probably the question most asked of sculptors, patineurs, and gallery personnel by collectors of fine metal statuary is, "How do I care for my bronze artwork?" Many sculptors and gallery owners are not knowledgeable concerning recommended maintenance programs which will help prolong the beauty, and in some cases, the lustre on the surface of your bronze sculpture. Traditionally, the patineur (artist of patinas) who has applied the patina finish and sealer, either wax and/or synthetic lacquers and wax used to seal and protect the patina and the bronze itself from the atmosphere, will transfer instructions concerning the care of individual bronze finishes to the artist, who in turn, passes this information on to the gallery where the bronze was purchased. With so many people involved in the handling of bronze artwork, information about its care tends to "get lost in the shuffle." As a result, the collector of bronze sculpture is then unaware of the basic care concerning his or her three-dimensional art investments which, in some instances, could jeopardize the lasting beauty of these metallic surfaces.

Therefore, this book was written for the collector of bronze artwork, in hopes of giving a better understanding of the care and

13

maintenance of bronze statuary placed indoors as well as outdoors. This book explains what bronze is composed of and why this easily oxidized metal and its intended patinas need protection from the atmosphere, lest color changes occur.

Tools needed for the preservation of bronze sculpture are discussed in length, as well as easy step-by-step instructions for the cleaning and preserving of these bronze treasures. Recommended maintenance programs are given for both indoor and outdoor bronze statuary. The author also describes common problems associated with the placement of bronze sculpture in various atmospheres, and how to avoid potentially harmful settings.

Although this book is geared toward the maintenance of new bronze artwork cast within the last 30 years, there is also information concerning the "ifs" and "whens" of maintaining the surfaces of antique bronzes. The handling of ancient bronze artifacts is also explained as well as the most desirable placement for their protection.

It is hoped that by reading this book, the collector of bronze sculpture will have a better understanding of the necessity of occasionally cleaning and waxing indoor bronzes, and the vital importance of protecting bronze sculpture placed outdoors. Unlike paintings, bronze sculpture is quite easy and inexpensive to maintain. By initiating a regular maintenance program, especially on outdoor bronzes, the collector is not only preserving bronze art treasures during his or her lifetime, but also for generations to come.

Introduction

We, as collectors, tend to think of bronze sculpture as "eternal." Once we purchase a piece of bronze artwork, many of us think that this bronze belongs to us. In actuality, we are merely paying for the privilege of serving as caretaker of a piece of bronze artwork on its long journey through time. As caretaker, the collector has the choice of either maintaining and protecting the patinaed (colored) surfaces of this metal, or neglecting these metal finishes, thus allowing changes to occur in the patina and possibly in the metal surface itself.

Patinaed bronze sculpture will darken with age, especially on statuary placed indoors. This is a natural occurrence with most bronze that is high in copper content. Today in North America, most art foundries are casting sculpture using bronze that generally contains 95% copper. Thus, modern castings of bronze will tend to "mellow," or its patina may tend to shift and darken more readily than artwork cast earlier in the 20th Century. Because these are newer castings, the patinas will be their freshest, or brightest. As they age, some colors within the patina may tend to change, in part because the copper within the bronze is beginning to oxidize. This natural occurrence of copper oxidation results in a black or darker coloration. How the patina was applied and how the finished surface was sealed, not to mention the environment in which the bronze is placed, will all determine how durable this

finished coloration is. Some sculptors, while working with patineurs (artists of patination), may choose patinas that are quite fragile, even to the touch, to be applied on their sculpted metal surfaces. These fragile patinas usually change most rapidly to darker tones. If the collector of newer bronze castings wishes to prolong the visual effects of these fragile patinas, as well as patinas that are much more durable, maintaining their surfaces is a requirement, although some patinas will darken quickly no matter how well a piece is maintained.

Maintaining the surface of bronze sculpture that is placed indoors is quite easy, in that all that is usually required is thorough dusting, wiping to remove fingerprints, and then the application of a **super-thin coat** of paste wax. This maintenance procedure not only helps keep the appearance of the bronze crisp and fresh, but it serves as a form of protection against its atmosphere. Because modern bronze (Everdur) oxidizes so readily, even natural oil from hands can darken patinas if the oils are not removed on a regular basis. Airborne dust particles become trapped in textured surfaces of bronze sculpture and may carry contaminants that will also tend to darken bronze. Food and drink can not only darken, but also add unwanted new coloration to the patinaed surface in the form of staining and spotting.

How often the collector chooses to clean and rewax a bronze sculpture depends on the environment of the bronze. In dry climates, with few household contaminants, an occasional cleaning and rewaxing, once a year or once every other year may be all that is needed, although with newer castings, once a year is recommended. In more humid climates and/or atmospheres containing higher concentrations of airborne pollutants, cleaning and rewaxing of the surfaces of bronze sculpture may be necessary as frequently as twice a year. This is especially true for bronzes placed outdoors.

Most older or antique bronze sculpture that was designed to be placed indoors has darkened, and the patinas on these surfaces have mellowed and become more stable with time. Thus cleaning and rewaxing these bronzes may be less necessary as these older patinas will usually tend to change less. In any case, if the collector has purchased or inherited a fine antique bronze of any great value, it is highly recommended to consult with a qualified conservationist prior to setting up any form of maintenance program, as waxing a particular older flat patina may disturb its overall

character and destroy the visual effect of its aged beauty.

The collector fortunate enough to purchase bronze artifacts should always contact a qualified conservationist for information as to their handling and placement. As opposed to newer or antique bronze castings, if these treasures of the "Bronze Age" were ever cleaned and waxed, it could destroy their beautiful "natural" patinas of crusty greens and blues, and greatly reduce their investment value. The best way to protect bronze artifacts and pieces of antique sculpture is behind glass, where surface contaminants are kept to a minimum.

There are many more considerations for the collector of newer bronze sculpture when deciding whether to maintain or ignore the surfaces of this metal when placed outdoors. Our changing environment determines what will happen to the surfaces of bronze sculpture. Manmade pollutants that are being pumped into the atmosphere become corrosive for any bronze sculpture, since many of these pollutants may attack the bronze itself. In these settings, the patina, although important, may tend to become less of a consideration than the metal itself.

The basic substance in nature that bronze finishes are to be protected against is water. Whether this water comes out of the tap or falls in the form of rain, surface chemical reactions take place, causing color changes in the patina and possibly the distortion of the overall appearance of the bronze sculpture. Harmful airborne pollutants, found predominantly in larger urban areas, become trapped in rain droplets as they fall through this contaminated atmosphere, and deposit on the surfaces of bronze sculpture. Depending on the concentration, these pollutants will determine how fast and in what direction the patina and surface will change.

In drier climates, patinas will tend to change slower as opposed to those in more humid climates. If the collector chooses not to maintain his or her bronze(s), then a risk is taken as to color change in the patina and possible damage to the surface. As all newer outdoor patinas age, they will tend to darken due to oxidation. Then as time passes, these surfaces will begin to lighten in coloration, if left unattended. This lightening of the patinaed surface is usually caused by foreign contaminants such as dust, that

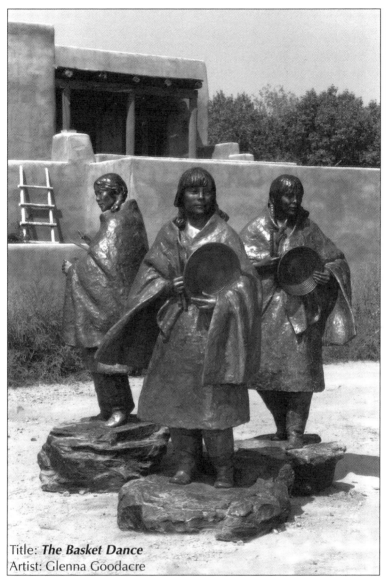

Title: **The Basket Dance**
Artist: Glenna Goodacre

Patinas on bronze sculpture placed in arid climates tend to require less maintenance. These bronzes are located in Santa Fe, New Mexico.

have become deposited on the surface of the bronze. Still later, if cleaning and waxing are ignored, the patina may begin to show signs of green coloration.

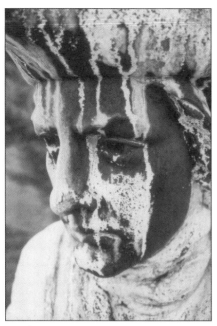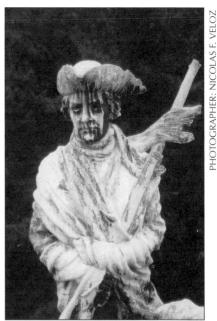

Title: **New Jersey Monument**
Artist: John Harrigan

This is a good example of what happens to bronze when left unprotected in a humid, high-sulfide environment (acid rain area). Photos taken prior to conservation treatment by the National Park Service in Valley Forge, Pennsylvania.

This "greening" of the bronze is held in high esteem by some collectors, but not with others. As this greening continues to develop, it forms streaks or "channels" of coloration that may break up the flow and movement of a bronze, as in the above photos. Eventually, other compounds develop on the surface that may be unseen to the naked eye, but traces of these new compounds can be seen in the form of surface distortion and metal deterioration.

Some collectors of outdoor bronze sculpture may request that their artwork remain looking crisp and new and attempt to prolong the visual effects of the original patina. In this case, a thorough washing and rewaxing twice a year, is usually necessary. If the collector wishes to create more of a weathered look to a patinaed bronze sculpture, then cleaning and rewaxing of the surface

only once a year may be sufficient. This of course, will depend on the atmospheric conditions surrounding the bronze surface. Many contaminants suspended in particular atmospheres may cause the surface patina to age more rapidly than in other less polluted environments.

Since water is the main carrier of harmful contaminants to the surfaces of bronze sculpture, especially fountains where water is either intentionally splashed up onto or runs over the metal surfaces, it is a major cause for concern. Fountains incorporating bronze sculpture tend to develop green and blue colorations within the patina in a very short time. There is not much that can be done to avoid this "greening" action, as it will eventually take over, no matter how much preservation work is performed by the collector. This natural greening of the bronze surface is regarded as quite valuable by many collectors and usually adds to the visual impact of bronze fountains. *Remember, any minerals suspended in water will eventually be deposited on the bronze's surface. Therefore, water that is quite alkaline, will tend to leave whitish crusty deposits on the surface; whereas, water that carries acidic contaminants will tend to leave greenish streaks and/or spots on the bronze fountain.* In either case, fountains composed of or incorporating the use of bronze will eventually change in surface coloration. Consequently, the collector of bronze fountains should anticipate these changes in the patinaed bronze surface.

Maintenance programs for fountains that are described later are designed to help the collector keep contamination of the surface to a minimum, but will not keep these metal surfaces from changing coloration, for this is the natural progression of bronze when in contact with water, especially over an extended period.

Remember, the idea of maintaining newer bronze castings as well as older ones, is to preserve their existing beauty. If the collector chooses to ignore the responsibility as "caretaker" of his bronze collection, then this beauty may be short-lived. However, if the collector enjoys the present visual effects of the bronze surfaces, then maintaining these investments in art will only encourage his preservation endeavors. Careful cleaning and rewaxing bronze statuary will not only extend the original beauty of patinas intended by the sculptor to be enjoyed by the present collector, but will also help in preserving the beauty of these metallic surfaces for the next generation of collectors to enjoy.

Chapter 1

Bronze,
A Brief History

*H*istorically, bronze has been the metal of choice as a medium for casting three-dimensional art we call sculpture. This tradition of pouring molten metal into ceramic or stone molds (casting), then retrieving an object, in bronze extends back almost 5000 years. From archeological excavations throughout the world, we know that bronze was used extensively by cultures throughout East Asia, the Middle East, Europe, and northern Africa.

Prior to 2500 B.C., prehistoric man used copper, as it was easy to manipulate into useful shapes by melting and/or forging, and it was quite abundant. This period in man's history when copper was used extensively is called the "Copper Age" by historians. Little is known of this age, because much of the copper that was used during this time was, later in history, also used in the production of bronze. However for reference, the Copper Age was at its

zenith during the building of the Great Pyramids of Giza in Egypt. (Imagine, using a soft metal such as copper to carve stone.) The Copper Age is also significant as this was the first period in man's history when metal was used on the battlefield as well as for domestic use. Spear points, swords, knives, helmets, and shields were all cast or forged from copper. Armies soon found these weapons to be much lighter and stronger than their wood and stone predecessors. Food preparation also changed drastically with the advent of copper utensils. Copper vessels were used extensively in the cooking of foods and for the storage of wines and other precious liquids. Land use was evolving as well due to the use of copper plows and axes in prehistoric cultivation.

As a result of population growth and increased demand for copper because of its many uses, prehistoric man eventually found supplies diminishing. During this time of dwindling copper supplies, man began experimenting with other castable and malleable metals. In Mesopotamia, tin was successfully used for tools as well as weaponry. Tin, however, had its limitations. Being more brittle than copper, it had its disadvantages. But when copper and tin were mixed together in a molten state making the first metal alloy, it contained properties which made it much stronger than either copper or tin. It is this mixture or alloy of copper and tin that we call BRONZE. The blades of bronze knives, axes, and swords held an edge longer than those of only copper or tin, and therefore were far superior on the battlefield.

As popularity of this new stronger alloy grew, so did its almost endless uses. From Europe to Eastern China, cultures were not only using bronze for domestic and military purposes, but also for religious and what we would consider artistic endeavors as well. We have found archeological evidence that small whimsical pieces were cast in the beginning of this "Bronze Age." As time passed and mankind grew fonder of this metal by continuous exposure to the workings of this alloy, he was able to cast larger and larger pieces in bronze. Life-size castings of horses were produced as well as adult-size religious deities. The height of the Bronze Age in the Western world is seen most prominently in Greece, where dramatic, larger than life castings of Zeus, and many other deities, were cast in one pour. This was a giant step forward in man's ability to work with molten metals.

Though bronze later declined as a choice of weaponry metal due to the onset of the "Iron Age," which began around 1000 B.C., it was to remain popular in the casting and hammering of artwork as well as for cooking utensils.

Newer Bronze Alloys

As many cultures expanded their knowledge of newer metals, bronze took on new mixtures, beyond the traditional copper/tin alloy. Metals such as zinc and lead were added, which gave bronze a richer and softer look. This newer alloy was and still is used in Italy and other parts of Europe. This particular alloy has been called Red Brass or Italian bronze. Other cultures developed very rich and exciting alloys. For example, China was using silver and gold in many of their bronze metallurgical creations.

Whatever mixture of metals was used in the manufacturing of bronze, the predominant metal has always been copper. Italian bronze is 85% copper, with 5% tin, 5% lead, and 5% zinc added. Many cultures in Asia still use the more traditional mixture of 90% copper to 10% tin.

As the demand for higher quality castings increased due in part to the "Industrial Age," so did the demands of the sculptor, collector, and foundryman. Many new and different sculpting techniques were requiring almost flawless surfaces. In the Americas, "Silicon Bronze" has become the alloy of choice for a quality casting. It pours more easily than most other bronze alloys. "Developed in the 1920s as a spark-resistant alloy for explosives manufacturing equipment, it became widely accepted, especially in the USA, for chemical plants." [1] As aluminum and stainless steel replaced the use of silicon bronze in these industrial settings, art foundries soon discovered its superb casting qualities. The use of this metal quickly spread throughout the art casting industry of the US until today, sculpture is cast in silicon bronze from East to West Coast, as well as many parts of Europe and in many countries in Asia. This most popular metal is composed basically of three elements: 95% copper, 4% silicon, and 1% manganese. It is from this interesting alloy that the vast majority of modern bronze castings are created.

1. Mike Excell, Columbia Metals Ltd. "Metallurgia", Volume 39, November, 1992, p. 407.

Chapter 2

The Patina

*T*oday, we define a patina as *"any intentional coloration placed on the surface of metal or wood whose sole purpose is to enhance and/or bring attention to these surfaces."* The creation of patinas basically involves the use of metallic salts suspended in acidic solutions, which are applied to the surface of bronze, thus achieving coloration. This application usually incorporates the use of heat, which helps in the chemical reaction on the surface of bronze, and therefore aids in the production of these unique colors and patterns. Commercial pigments are sometimes added to the patina to help warm or cool a particular color desired. Because these patinas are usually quite fragile to the touch, and applied to metals that are easily oxidized when exposed to the atmosphere, these patinas need to be sealed with lacquers and/or waxes in order to help retain their unique coloration.

Originally, patinas were thought of as *"the coloration of metal and wood brought about by the oxidation of surfaces, caused by*

extended exposure to its immediate atmosphere." Bronze, being primarily copper, tended to oxidize or tarnish quite easily, allowing objects in cast bronze to take on different appearances as time passed. A deeper corrosive action occurred on bronze objects that were laid in ancient burial tombs, due to high acidic atmospheres or alkaline soils which came in contact with the surfaces of these metal objects. This exposure over time gave bronze surfaces green and blue crusty coatings, which today are regarded as quite valuable in the art world as well as in the field of science. These pieces of antiquity took on what are considered "natural patinas." For centuries during the Roman Empire, people tried to artificially color bronze objects to resemble the green and blue effects of this natural patina.

It wasn't until the emergence of the alchemist in the middle of the Dark Ages that we find a new spark of interest in the coloration of metal. This interest was based on the attempt to change base metals into gold or have the surface coloration resemble the aesthetics of gold.

During this time and continuing on into the European Renaissance, the true blossoming of bronze patination came into its own in the Western world, especially as an art form. Not only were patineurs achieving the effects of natural patinas, but they were also creating new and more lasting effects by introducing new innovations such as wax and oil sealers, used to prolong the effects of patination on the surfaces of bronze sculpture. Waxing bronze surfaces to seal and protect the patinas was all that was needed at this time, as the alloys of the day didn't usually have extremely high concentrations of copper, and there was no better choice of a sealer than wax for protection against the atmosphere.

Today however, we in the Western world are producing bronze sculpture cast from silicon bronze, which is quite high in copper content. As a result of this high copper ratio, patinas on sculpture cast from silicon bronze tend to change more readily, darkening and subduing brighter colors and patterns. Almost all bronze darkens as it ages; patinas tend to mellow with age, which is caused by chemical reactions finding a balance on the surface. This natural occurrence whereby the copper content in the bronze oxidizes, giving a dark black coloration, is only one of the many mellowing procedures.

There is much discrepancy between patineurs and foundry personnel in general as to the correct procedure for sealing bronze sculpture to protect it from our contemporary environments. Many people applying patinas still regard wax as the most traditional sealer, and therefore, that is what is used. This procedure is not always adequate, because when dealing with sculpture cast in silicon bronze, wax in many cases, does not give sufficient protection from the development of copper oxides. Therefore, many foundries today have gone to hard sealers, i.e., synthetic lacquers and varnishes, which extend the original patina, keeping colors brighter longer. These lacquers and varnishes have one major drawback however. They may become too glossy, causing a "plastic look" to a finished bronze. Therefore, following tradition, as well as to protect the lacquer or varnish finish, the bronze surface is then waxed.

Aesthetics of the Collector

Many sculptors prefer to allow their bronze surfaces to age naturally, darkening and subduing the original coloration, while others prefer to have their original work look like new for an extended period of time. This may be confusing for the collector if he or she does not know the original intent of the sculptor. Therefore, if possible, it is always advisable for the collector to find out as much as one can about a particular modern casting from either the sculptor, gallery personnel, or art foundry where a particular piece was cast and/or patinaed. This may eliminate unwanted surprises from changes in the patina later on. Of course, this search will be in vain when purchasing an antique bronze from the 19th and early 20th Centuries. Therefore, at this point, it is completely up to the collector as to how or even if the surface of a bronze sculpture will be maintained. This choice alone is based on the aesthetics of the collector. *However, please keep in mind that a nonmaintained bronze is also an unprotected one.*

Chapter 3

Caring for
Indoor Bronzes

*T*here is a basic truth when purchasing bronze. As collectors we buy a particular bronze because it brings happiness into our lives, and/or we purchase bronze artwork for purely investment purposes. Whichever the case, the hidden responsibility in buying a bronze is that we are given the privilege of caring for a particular casting or castings during our lifetime. A bronze may be handed down from generation to generation, or may be sold time and time again on the art market, or it may be a new casting from a living sculptor. In any case, especially with antiques, a bronze has gone through or will go through the lives of many people. As a collector, you are only one of many that will care for and maintain a bronze on its long journey. Taking care of bronzes now will help preserve their beauty for generations to come.

Maintenance vs. Neglect

Keeping the patina newer looking, or letting it darken on its own as stated previously, is completely in the hands of the collector. If a bronze surface has a particular shine to the finished patina, then in order to maintain that lustrous effect, the surface of your bronze sculpture should be maintained by waxing. However, if a bronze is purchased with a matte patina, it is best not to wax the surface as waxing may darken, but will surely shine an otherwise flat surface when buffed with a soft cloth. Also, it is best not to attempt to wax a polished (like a mirror) bronze surface, as this will also dull the high reflective finish and possibly leave scratches in the soft surface of the metal caused by the bristles of a brush or the coarseness of the buffing cloth.

The following information is for the maintenance of late 19th and 20th Century bronze castings, as most of the time, these castings have a final coat of wax over a lacquer hard finish. Also, most bronze cast during this period was or is shown or was originally purchased with a shiny wax finish. As mentioned before, there are exceptions to this rule.

Care of Modern Bronze Castings

Hopefully your new bronze and patina have been primarily sealed with a synthetic lacquer. The reason is that your patina will be better protected and will last longer. If your bronze sculpture is waxed only, then you may see a slow darkening of the patinaed surface, which is quite natural. In either case, you will want to wax the surface of your bronze in order to help maintain the beautiful patina that was on the surface of your bronze sculpture when you purchased it.

Remember that all bronze darkens as it ages, but by waxing the surface of your sculpture, you may be able to slow this oxidation process for a time.

Tools Needed for Maintaining Indoor Bronze Sculpture

The tools needed for maintaining bronzes placed indoors are quite simple and readily available. Most hardware stores carry what you will need for this easy task. It is important to consider that it is the patina you are caring for more than the bronze itself, when you are maintaining a bronze that is placed indoors. These indoor patinas are usually much more delicate and fragile than those applied to the surface of bronze that is to be placed outdoors, and this is one reason that the care of your bronze sculpture is necessary in order to maintain these surface colorations.

Brushes come in all shapes and sizes. The size recommended for the task of bronze maintenance depends on what you're comfortable with. For table-top size bronzes, one to two-inch wide paint brushes are recommended. It is unimportant whether the bristles are synthetic nylon or natural hair bristles. What is important is that they are clean and free of any dirt or oil. Any remaining paint stains on an older used brush may transfer over to the wax, depositing unwanted color, which may drastically disturb the flow of the piece.

The author recommends purchasing new brushes for the purpose of maintaining a bronze as they are far less expensive than a re-patina. Purchasing "Chip" brushes is a good idea for maintaining bronze because they have natural soft bristles, and they are inexpensive, as far as brushes go. Most hardware stores will carry these Chip brushes.

Two brushes are recommended for the task of bronze maintenance. The first will be used in the initial dusting or cleaning stage, and the second will be used to transfer wax from its container to the bronze surface.

On most brushes, the bristles are attached to the handle with a metal ferrule. In order to avoid making scratches in the patina with this metal ferrule, wrap the ferrules with masking tape as in Figure 1 (page 33). These brushes should be placed in plastic bags or plastic wrap to keep them clean and free of foreign contaminants for future use.

Wax is the most traditional sealer and protector of the patinaed surface of a bronze sculpture. There are many homemade

recipes for making wax to be applied to bronze. However, many of these will only work on certain patinas, i.e., homemade wax mixtures that are made for applying to dark patinas may also darken lighter ones permanently. *Therefore, using commercially available prepared paste waxes is recommended.* Paste waxes need time to dry prior to buffing, and different waxes dry at different rates. Some of these drying rates are important when dealing with light patinas and also with large collections where time is essential.

One of the safest waxes recommended for use on a patinaed bronze surface is clear <u>Trewax</u>® <u>Brand Paste Wax</u>. It contains carnauba wax, which is a wax extracted from Brazilian palm trees, and is one of the hardest waxes available. It is the only other natural wax besides bee's wax. The carnauba wax in Trewax is suspended in turpentine, which gives this wax its creamy consistency and allows the carnauba wax to be transferred to the brush. Make sure that the lid remains on the can when Trewax is not in use as the turpentine will continue to evaporate and thus harden the remaining wax in the can. *Trewax is highly recommended for light or dark patinas.*

<u>JOHNSON</u>® <u>Paste Wax</u> is another wax recommended for use in maintaining the surface of bronze. *However, some paste waxes may permanently darken light patinas and therefore is recommended for dark patinas only. This wax gives excellent protection to dark patinas and has the ability to produce a nice lustre when buffed.*

<u>Renaissance Wax</u> is yet another commercially available wax recommended for bronze protection. However, it may be difficult to find. Many art supply stores carry this wax, or can probably order it upon request. *This is a good hard wax that goes on well and shines easily.*

<u>Kiwi</u>® <u>Neutral Shoe Polish</u> is the wax of choice when a high gloss is recommended. *However, this wax may darken lighter patinas and therefore is recommended for medium to dark-valued patinas.* This wax may be layered over Trewax if necessary.

Buffing cloths are needed to smooth and shine the wax once the mixture has dried on the surface of the bronze. Use only clean, dry, cotton towels, Handi Wipes, old socks, etc., to rub the surface to a shine. *Low-lint cloth is recommended as this will keep the surface cleaner.*

Application

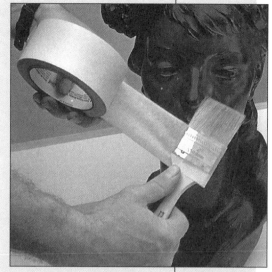

Step 1. Wrap the metal ferrules of two clean paint brushes with masking tape to avoid accidental scratching of the patina.
Figure 1

Figure 1

Step 2. Using a soft, clean cotton cloth, gently wipe the surface free of any dust and fingerprints.
Figure 2

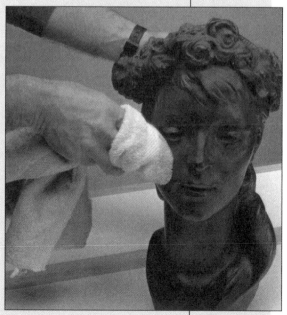

Figure 2

33

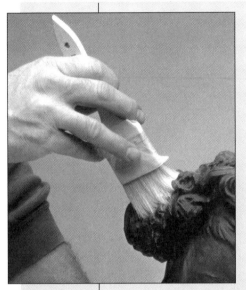

Clean deeper crevices or recessed areas of the sculpted surface with one of the ferrule-wrapped brushes. Then write "for dusting only" on the handle and place it in a plastic bag for future use. *Figure 3*

Figure 3

Step 3. Inspect the surface at this time to see if there is any damage to the patina. Check for surface contaminants such as fly spots. These may be easily removed by using a damp cloth to gently wipe the spots from the patinaed surface. This also works well for removing other contaminants such as food residue left on the surface by sticky fingers. Jewelry such as rings and watches can scratch a patina quite easily, so look for signs of minute scratches that can be seen in the form of small brassy lines in the patina. Also, look for any changes in the patina, i.e., getting darker or richer.

Step 4. Open a can of Trewax, or whatever wax is chosen (see section on wax) and using the second ferrule-wrapped brush, lay the bristles across the wax surface back and forth in a sweeping motion. Three or four strokes should do it, (fewer with JOHNSON Paste Wax). *Do not dab the brush into the can of wax as this will overload the brush.* You don't want to overload your brush as this will result in a longer drying period and possible wax buildup. There is the possibility that too much wax

can harm or even destroy a patina. Therefore, carefully place a **super-thin coat** of wax on the surface of the bronze in a gentle sweeping motion. Gently work the brush down into the crevices as you apply the wax. *It is important to note that wax can soften and remove other layers of wax.* This is why it is essential not to apply too much wax or become too vigorous in applying paste wax to the surface. Also, over-waxing a bronze patina can shift and remove pigments suspended in waxes originally placed on the surface as part of the patina to accent or warm patina coloration. *Figure 4*

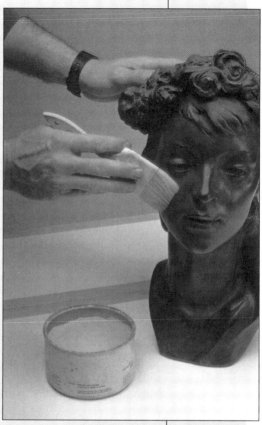

Figure 4

You will be able to tell where you have waxed as the surface will be matte and not shiny. It is also important to note that lighter-valued patinas may darken when first waxed, but as the wax dries, the patina coloration should return. This is why Trewax is recommended as it has the shortest drying time and changes lighter patinas the least.

Continue waxing until the entire surface has been covered. Allow the wax to dry (follow the directions on the wax container as to drying time). Then place the wax brush in a labeled plastic bag to keep it free of contaminants for future use.

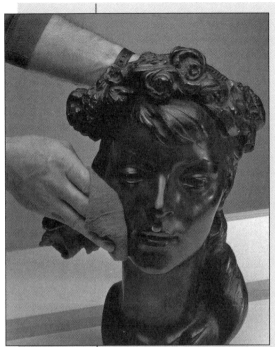

Figure 5

Step 5. Using a clean, dry cotton cloth, begin gently rubbing the surface of the bronze until the desired shine appears. Work the cloth in a circular motion on large smooth areas of the surface. *Figure 5*

Step 6. Repeat Steps 4 and 5 if necessary for a better protective coating.

Recommended Maintenance Program

Cleaning and waxing an indoor bronze sculpture at least once a year is recommended, possibly twice a year in humid or corrosive environments. *Never use spray or liquid furniture polishes to dust or clean bronze sculpture* as many of these products contain oils that can soften initial wax coatings, thus darkening lighter patinas. Also, many of these polishes contain cleaning solutions that could strip away protective wax coatings. *Never use cleaning solvents such as turpentine, xylene, etc., on the surface of bronze sculpture* as this may strip away protective wax and lacquer coatings and may also destroy the fragile patina.

The Care of Antique Bronze Sculpture

By using the word antique in the world of bronze sculpture, one may be confused as to what is considered antique. One definition of an antique bronze sculpture is a bronze that was cast prior to 1890 A.D. Since silicon bronze was developed in the 1920s, it follows that there are no antique bronzes cast in silicon bronze.

Before any maintenance program is established and if the bronze is of any great value, it is highly recommended that the collector contact a qualified, experienced conservationist and/or museum curator. One of the easiest ways of finding a qualified conservationist in your area is to contact the American Institute for Conservation of Historic and Artistic Works in Washington DC. They will be able to help you with this task. There is no fee for this service but donations are gladly accepted.

Most antique bronze sculpture cast in the Western world prior to the 1890s would have been cast either from alloys containing the traditional copper-tin mixture or more likely the more common copper-tin-zinc-lead alloy which we call Italian bronze or Red Brass.

As mentioned earlier, all bronze darkens as it ages. This darkening is usually the result of the primary metal—copper—developing oxides which are black. Red Brass or Italian bronze however, containing tin, which develops white oxides, as well as zinc and lead which also produce white oxides, tend to create a softer, more powdery finish to the patina , especially in crevices, producing an overall lighter look to a dark patina. This "older" natural effect, due to these lighter oxide developments, is usually the result of the lack of maintenance on the bronze surface over the years. Aesthetically, these indoor antique patinas may be quite pleasing to the eye and, in many instances, are considered quite valuable.

However, if an individual inherits or purchases an antique bronze sculpture and the surface patina is somewhat shiny, containing a deep lustre, then it probably has been minimally maintained over the years and/or handled extensively, as hand oils have darkened the patinaed surface. If this is the case, then it is suggested to go ahead and wax the piece, keeping in mind that *the first initial wax coating may permanently darken the existing antique finish.*

Care of Bronze Artifacts

Almost all bronze artifacts available for purchase on the art market will have what is termed a "natural" patina (see Chapter 2). These natural patinas, crusty colors of blue and green, take centuries to produce, and this is what gives bronze artifacts their unique characteristics of age and aesthetic value. Because these natural patinas are usually quite delicate, even hand oils can darken and mar their incredible beauty.

Therefore, it is always recommended that these pieces be handled only wearing clean, soft cotton gloves or with a clean soft cloth, to avoid further oil contamination. It is also a good idea to display bronze artifacts behind glass, as this will allow fewer contaminants, both airborne and from hands, to come in contact with the patinaed surface. It is always advisable to consult with a conservationist specializing in bronze artifacts for advice on the handling and displaying of these ancient bronzes, as there so many factors to consider in preserving this artistic inheritance from our historic past.

Placement of Indoor Bronze Sculpture

Many people think that bronze statuary in their possession can be placed just anywhere in their homes or businesses with little concern, because after all, they're made of indestructible bronze. This idea is only partly true because of one important consideration—the patina.

Bronze as a metal is quite durable, whereas the patina on the surface of the indoor bronze sculpture may be quite delicate. Factors such as humidity, sunlight, temperature, and air flow all play major roles in the protection of the patina. High levels of humidity may cause patina shifting, spotting, and the eventual development of bluish-green dusty spots or streaks on the patinaed surface, easily noticed on darker patinas.

Therefore, if no changes in the patina are desired, it is best to keep bronze sculpture away from sinks, bathrooms, humidifier vents, hot tubs, and swimming pools. Swimming pools, both indoors and out, can be quite damaging, not only to the stability of the patina, but also to the bronze itself. Chlorine added to pool water is given off in the form of chlorine gases on the surface of the water. It is these gases that are then deposited on the patinaed bronze surface, producing copper chlorides, which may be quite corrosive to the patina and metal beneath. If a swimming pool setting is chosen however, keep the bronze as far from the water's surface as possible, and a safe distance from splash and limited air flow.

Sunlight and temperature may be as damaging to the indoor bronze patina as water. This is especially true of light-colored patinas whereby the sun's rays heating the surface can soften the protective wax coatings, which then penetrates the patina layers, thus permanently darkening the finished coloration.

Also, the little known practice of placing sculptor's wax in casting pits and other flaws on the bronze's surface can melt and shift, thus accentuating these flaws more than hiding them. Ultraviolet rays in sunlight can also fade pigments added to wax coats

or the chemical patina itself. In many instances, sunlight is capable of causing chemical reactions within the patina itself, thus creating different chemical compounds not found in the original patina, which in turn results in possible unwanted coloration.

This is seen time and time again on modern bronze castings of silicon bronze where light blue and/or green patinas, produced by the use of the chemical compound cupric nitrate, develop dark blood-red patches of coloration within the patinas. This coloration/chemical shift can be quite frustrating for both the collector and patineur (an artist of patina application). Therefore, for the best protection of the patina, it is advisable to keep bronze sculpture with patinas applied for indoor placement, out of sunlight and extremely high temperatures.

The following is a list of commercial household products that should never come in contact with the patinaed bronze surface, as unwanted changes in the patina may occur:

- Bleaches
- Oven cleaners
- Glass and porcelain cleaners
- Any other strong or weak cleaning solvents
- Steel wool and scouring pads
- Vinegars
- Plant fertilizers
- Furniture polishes

Other liquids in the form of beverages found in the household, which are damaging when they come in contact with patinaed bronze are:

- Alcoholic beverages
- Soft drinks
- Citrus fruit juices

Other Members of the Household

Believe it or not, some pets have the ability to damage patinas on bronze sculpture. The most common problem with pets concerns **male dogs**, for they are attracted to copper and may find it a convenient territory marker, if bronzes are placed within their reach. **Cats** too have been known to leave their mark on bronze, but they are most famous for accidentally knocking bronze sculpture from shelves and table tops. **Birds** left uncaged in a home can also damage bronze sculpture as their droppings may be quite acidic to the surface of bronze. If a bird does happen to spot a bronze, it is best to use a damp cloth to remove the droppings as quickly as possible, and then dry the surface. A rewaxing in that area is usually recommended.

Do not place a bronze sculpture next to **fish tanks,** especially those aquariums containing salt water, as the minerals in this water can be quite damaging to the patina as well as the bronze surface itself.

In conclusion, the ideal indoor placement of bronze sculpture is out of sunlight, away from water, household cleaning solvents, high temperatures, and most pets. Rooms in the home where bronze patinas are most likely to change are in the bathroom, kitchen, and swimming pool room. Bronze sculptures are best protected in other rooms where contaminants are kept to a minimum, and air flows freely. If bronze sculpture is placed in environments that are suitable for the bronze, the original coloration or patina should last successfully for many years and bring pleasure to the present collector as well as those to come.

Chapter 4

Caring for Outdoor Bronze Sculpture

*T*he care of bronze sculpture that is placed outdoors is probably one of the most controversial topics among sculptors, patineurs, conservationists, and museum curators. Many sculptors request their sculpture that is to be placed outdoors remain looking like new, while others prefer to let their art work age naturally, letting corrosive compounds in the atmosphere attack the surface of the bronze, which create flat colors such as black, gray, and green streaks or channels as the bronze ages. Still other sculptors like to show a small amount of aging, letting the patina mellow with time.

As many sculptors are unaware of the potential surface dangers that await their bronze sculpture when placed in the elements, this decision is usually based more on aesthetics than to the potential damages not only to the patina, but to the bronze itself that occurs over time.

Why Maintain Outdoor Sculpture?

As most conservationists that specialize in bronze sculpture know, the exterior elements can play havoc with a bronze surface, especially if left unprotected. Problems vary from climate to climate as seen by the author, traveling from coast to coast, studying atmospheric conditions and its effects on bronze sculpture. Bronze sculpture placed in rural, airy, underpopulated areas, tend to darken and change patina coloration at a slower rate. In these drier climates, the main concern is usually with the protection of the patina. Whereas, in urban areas where sulfide pollution from car and industrial exhaust, not to mention a higher humidity level due to population concentration exists, the patina becomes a minor concern as opposed to the more major problem of the bronze itself. The atmosphere of urban settings is becoming more and more corrosive to bronze as evidenced by bronze sculptures that have been studied over a long period of time.

As these harsh atmospheres come in contact with bronze surfaces, they deposit foreign corrosive compounds, which then react, usually with the copper found in bronze, causing color changes in the patina and pattern changes in the form of green streaking, which may break up the flow of the piece. If left unchecked, these compounds will develop further compounds eventually leading to surface damage and such surface mutilations as pocking and cracking. Although this final deterioration process may take years to develop, it will eventually weaken and surely destroy the bronze surface.

What is causing this deterioration in many instances, is acid rain, seen most predominantly in the eastern United States. This acid rain is a common problem now in many urban settings, because as rain falls through an atmosphere containing high levels of sulfide pollutants, it picks up traces of these sulfide compounds, thus changing a clean rain shower into a mild sulfuric acid bath. One of the first signs of attack by acid rain in humid environments is a green streak or channeling pattern on the bronze surface. Eventually, green and gray coloration patches expand over the surface until the entire piece is somewhat green. The green colorations are copper sulfates, a by-product of this acid bath attacking the copper within the bronze alloy.

Surfaces of bronze sculpture develop many more copper compounds, not only from airborne pollutants, but also from insects,

birds, and tree saps. Eventually, these contaminants will cause reactions to occur with the bronze surface, thus creating new and different colors. They may also deteriorate and etch the metal itself.

If the design of a bronze sculpture is such as to encourage people touching, rubbing, or climbing on the surface, this too invites scratching and other sealant disturbances, which will leave metal exposed to an unfriendly environment , causing further deterioration of the patina and bronze surface.

Therefore, in order to keep bronze sculpture protected from these extreme and damaging conditions, it is best to initiate a maintenance program which keeps the surfaces clean and waxed, thus giving years of beauty to bronze artwork.

Aesthetics of the Collector

For a collector of outdoor bronze statuary, the decision to protect these somewhat delicate surfaces from the elements by initiating a maintenance program, or to allow the protective sealers and patinas to deteriorate, with the possibility of surface damage later on, remains at his or her discretion.

The climate in which you, the collector, may choose to display these bronzes will help you decide how or if you need or want to clean and protect your art investments. As mentioned earlier, all bronze patinas first begin to darken as they age. This is especially true of patinas placed on silicon bronze. The climatic atmosphere of your bronze(s) and their patinas, if not maintained, will determine what coloration changes are next to develop. *In humid, acidic atmospheres found in many large urban areas, green spotting and streaking will occur.* This color, in a small amount of time, will completely cover the surface of bronze, possibly breaking up the flow and movement of the piece. However, in more arid climates found in the Western states, it may take years before any signs of green coloration appear. *In these dry climates, maintenance programs may be less demanding due to fewer airborne contaminants.*

There is also the question of the patina itself. In most areas of the United States, especially in the West, darker patinas will tend

to lighten with time as a result of dust particles being trapped on the surfaces and washed into crevices by rain water. Also, protective wax coatings tend to lighten as they age. Lighter patinas, on the other hand, will tend to darken, due to dark new chemical compound developments from such things as sunlight, dust, and smoke, not visibly seen on darker patinas. *Therefore, if the collector chooses to keep his or her dark bronze patinas, an active maintenance program should be initiated. This goes for lighter patinas as well, for once they darken, it may be impossible for the collector to lighten them again.*

Many sculptors will choose patinas for their outdoor sculpture that may be too delicate and fragile for the harsh elements. In most instances, the collector will be unaware of this until changes in the patina occur rapidly once the bronze is placed outdoors. If these changes are found pleasing, then there is no problem. However, if the patina was a major reason for the purchasing of this art work, and if the change is displeasing to the eye, then either the gallery and/or sculptor should be contacted. As the author is a master patineur, he, along with most other artists of patination, appreciate feedback from the collector either through the sculptor or gallery owner as to the performance of the patina over time. This determines new and more innovative patina applications and protective sealers, which help the collector in the long run.

If the purchasing of bronze monuments (larger than life-size) is the aim of certain collectors, please keep in mind that most monuments usually appear in public settings and so more than aesthetics may be involved when choosing the pros and cons of maintenance programs. A responsibility comes with publicly displayed art, that is possibly unrealized or unnecessary to the collector of smaller outdoor bronzes. There is a civic duty to the community to ensure that ongoing maintenance programs are initiated, to guarantee that this beauty is preserved for the enjoyment of others in the future.

Therefore, if the collector of outdoor bronze sculpture wishes to ignore maintenance programs designed for surface protection, the risk may be quite high for patina shifting and later surface damage. Whereas, if an outdoor bronze sculpture is well-maintained on a continual basis, the initial beauty may last for generations.

The Care of Modern Outdoor Bronze Castings

If a bronze sculpture that you have purchased was cast in the U.S. and is a casting within the last 30 years, it is likely composed of silicon bronze, which is an alloy containing 95% copper, 4% silicon, and 1% manganese. As this bronze alloy is quite high in copper content, it will tend to darken faster and also produce bluish-green coloration faster than other bronze alloys of the past, which contain 85% copper on the average. If rapid color shifts or changes in the patina and eventual surface damage development is a concern, then a continual maintenance program is essential.

This responsibility is not a difficult nor expensive task to undertake. It just takes time. But it may be time well spent, as this gives the collector a chance to work on the surface of his or her bronze collection, thus becoming more intimate with the intents of the sculptor, foundryman, and patineur. If studied closely, the casting quality and metal finishing become more apparent, which may give the collector a truer appreciation of the immense time and labor involved in the creation of bronze sculpture. It also allows the collector an opportunity to become better acquainted with the environment by studying the effects it has on the outdoor bronze sculpture.

If a bronze with a matte surface finish has to be maintained, using wax may not be the desired choice of a protective sealer, as this may darken, but will surely give a sheen to the outer surface. If that matte finish is to be maintained, it is advisable to first contact the gallery, which will then contact the sculptor (if living), for instructions. In many cases, a matte finish incorporates colors such as greens and grays, and *in this case maintenance may only require a simple washing with a neutral detergent and water,* as the intent of the sculptor may be for the piece to weather "naturally," and become greener and brighter, as it ages.

Outdoor bronze sculpture that is purchased with a shiny finish over the patina usually indicates that a maintenance program is an important consideration. The outer sealer used first is usually a coating of protective paste wax. Sealing bronze surfaces against exposure to the elements is traditionally done with two or more coats of wax, or more recently, with synthetic lacquers and then additional coatings of wax. The latter has proven to be a far superior sealant combination in many instances than wax layers alone.

This outer wax coating on the surface of outdoor bronze has a dual purpose; to enhance color, richness, and depth to the patina which affects the overall appearance of the piece, and at the same time, to protect the patina and surface from rapid decay. If the collector wants to maintain this particular effect, it is important that these wax coatings be replaced on a regular basis, as they deteriorate and wash away in a short time, exposing the patina, and more importantly, the surface of the bronze itself.

More is involved in the maintenance of outdoor bronze sculpture than the care of bronzes placed indoors. Patina colors, their values, patterns, and textures, all play a role in how and when a bronze should be maintained. Maintaining dark brown patinas may require different steps in its maintenance program than lighter green, beige, or even white patinas.

Basic brown patinas, or what we today refer to as transparent brown or "French" brown patinas are the simplest to maintain in that all that is usually required is a thorough washing and rinsing. After it is dry, one or two coats of paste wax are applied, left to dry, then buffed. *For dark brown transparent patinas in general, it is best to apply paste wax to these patinas in late spring and early autumn, in the heat of the day, when the surface of the metal is fully exposed to the sun's rays and the surface is warmest.* This will give better protection because the wax is able to penetrate into the expanded metal. The surface of the bronze should be allowed to cool and then be rubbed gently with a clean, soft cotton cloth until the surface becomes glossy. While the surface is still cool, apply a second thin coat of wax, allow it to dry, then buff the surface to a glossy finish. *As the purpose of this warm waxing method is to keep these dark and medium range transparent brown patinas dark and rich, it is not advisable for the waxing of lighter-colored patinas, or those patinas in which the collector wants the overall appearance to remain the same as prior to cleaning and waxing.*

The best time to clean and wax bronze sculpture with lighter-valued patinas may be different than maintenance programs for patinas of darker tones. *It is recommended to choose a clear warm day in spring and again in fall.* The surface of the metal should be washed and rinsed thoroughly during the warmest part of the day, allowing time for the surface to dry thoroughly. In the evening, when the bronze has cooled and the surface has dried, is the ideal time to apply one or two coats of protective wax,

allowing time to dry and buff after each coat.

Multi-patinas, or those patinaed surfaces that contain more than one patina or color, should always be waxed carefully in the cool of the late afternoon. They should be handled as if they were light-colored patinas, as in many instances certain coloration may have been achieved by the use of pure ground pigments that are worked into the patina and/or wax. By carefully waxing the surface while the bronze is cool ensures that these pigments won't run or shift, changing colors on other areas of the surface; whereas, *if multi-patinas are waxed when the surface is warm or hot, these pigments may run, and darken lighter patinaed areas as well.*

Since maintenance programs for outdoor sculpture deal with larger surfaces than those normally associated with indoor care, waxing a cool bronze surface may take more time, as it is advisable to apply, let dry, and buff these large surfaces in small sections. Additional help may be required for the waxing of monumental bronze sculpture, as this task should be carried out in one evening if possible. This avoids overnight contamination of foreign particles deposited on the clean surface by dew or frost, which would then be trapped under subsequent layers of wax.

In conclusion, it is best to clean the surfaces of bronze sculpture containing dark or light patinas in the heat of the day, allowing time for the bronze to dry. Then for dark patinas, applying paste wax to the warm bronze surface is recommended; whereas when waxing lighter-colored patinas, a cool surface is necessary for maintaining the original intended coloration.

Tools Needed for Maintaining Outdoor Sculpture

The materials needed for maintaining modern castings of outdoor bronze sculpture are usually very easy to find and quite inexpensive. Most tools needed for this job can be found at hardware and janitorial supply stores, as the clerks are generally more familiar with their products, which is very helpful when searching for neutral detergents.

Prior to waxing the surfaces of outdoor sculpture, it is necessary to thoroughly clean the bronze, removing any contaminants

that may be causing present discoloration, or which may result in future patina shift or color development due to these unseen contaminants trapped under subsequent layers of wax.

The best way to clean these outdoor bronze surfaces utilizes **clean running water** transferred to the sculpture site by means of a garden hose, preferably one with some sort of spray nozzle attachment. As a rule, water siphoned or pumped from ponds and rivers should not be used to clean bronze sculpture as this water may be too acidic or alkaline and may deposit more unwanted contaminants on the surface of bronze that may be harmful to the patina, and/or finish.

The use of **soft, non-metallic scrub brushes** is essential for the cleaning of surfaces, especially in textured areas where the bristles are able to loosen dirt from the deep recesses of heavier texture. Plastic or natural bristle scrub brushes are recommended for the job of cleaning bronze surfaces as they will usually not scratch or cause any form of chemical reaction with the patina or bronze. *Never use wire brushes or steel wool pads (or scouring pads of any type) to clean bronze sculpture.*

A **non-ionic or neutral detergent** mixed in water is necessary to help loosen and lift unwanted pollutants from the surface when using a scrub brush. These detergents are usually more environmentally friendly, both to the bronze surface as well as to the surroundings of the sculpture. Many household detergents are not recommended for cleaning bronze, as some of these household cleaners contain chemical compounds that could disturb the patina as well as react adversely with the bronze surface. Some of these cleaners may also tend to "fog" the outer protective wax coating, which may require extensive work to correct. Most janitorial supply stores carry a line of neutral detergents. It is always best to follow directions for recommended concentration mixtures which are usually found on the detergent bottle's label. *It is never recommended to place concentrated detergent directly on the surface of bronze,* but rather, to mix the appropriate amount of detergent and water in a non-metallic bucket first. Then dip the scrub brush into the soap mixture and apply the detergent to the surface in order to release and remove unseen and unwanted pollutants, rinsing as you go.

Some people prefer to use portable pressure washers to clean the surfaces of their bronze sculpture. Although this process can

loosen and lift many contaminants from the surface, it leaves a considerable amount of contaminants (usually seen as a chalky film) that only a scrub brush and a little elbow grease can remove. *The author does not suggest the use of these pressure washers for bronze maintenance,* as water is projected at the surface with great force. If there are any unseen "shrink patches" or porous clusters in the casting's surface, water may be forced into these areas only to return later, in the form of white or bluish-green spots, which are then visible under the subsequent wax coatings. This is not desirable as it draws attention to unseen casting flaws on the surface of the bronze. These spots may be difficult to eradicate from the surface without using the expertise of a master patineur and/or experienced conservationist.

Wax is probably the most important component of a maintenance program for outdoor bronze sculpture, for when placed on the surface of bronze, it helps to protect the patina and bronze from the elements, while giving extended life to the initial patinas and to the bronze itself. When purchasing wax in paste form, *it is important to know that certain waxes should be used only on certain patinas, as some waxes may darken light patinas, while other waxes may leave an unwanted buildup or staining effect on the surface.* Commercial paste waxes are recommended as these waxes are easily available to the public, eliminating the messy task of mixing wax into paste form.

Clear Trewax Brand Paste Wax is highly recommended as a protective coating for outdoor bronze sculpture as it is quite durable and *can be used on dark, and even more importantly, on light-colored patinas.* Trewax has a fast drying time and therefore, should be applied, left to dry, and buffed in small sections of large surfaces. This hard wax is a composition containing carnauba wax suspended in turpentine. Carnauba wax is a natural wax which is extracted from Brazilian palm trees and is the only other natural wax besides bee's wax. *Trewax Brand Paste Wax should be applied in thin coats as wax buildup can occur rather quickly. This wax should always be applied to a cool surface, whenever possible, for best results.* If Trewax is applied to a warm surface, it may darken lighter patinas and leave a visible "Mud Pack" effect on darker ones. Always place the lid back on the can of Trewax when not in use as the turpentine, which is the softening agent in Trewax, will evaporate, allowing the carnauba wax to harden.

When Trewax is first placed onto the patinaed surface, the coloration may darken, and intentional patterns found within the patina may disappear. This is short-lived, however, because as the wax dries on the cool bronze surface, the color(s) and patterns slowly return. The moment the colors have returned is the time to shine the waxed surface. Using a cloth to shine the surface before the wax has dried will only push this soft wax deeper into the patina, possibly causing color smearing and/or distortion.

Placing too much wax on a patinaed bronze surface in combination with the heat given off by the sun's rays may also darken the patina. However, with Trewax this problem is momentary, because Trewax will allow the colors to eventually return. This is why *Trewax Brand Paste Wax is highly recommended for light patinas and those patinas where little or no change is requested in the appearance of the bronze.*

JOHNSON® Paste Wax *is highly recommended in the maintenance of darker patinas on outdoor bronze sculpture.* This wax mixture is much thinner than Trewax and so will flow easier as well. There are pros and cons to this however, as JOHNSON Paste Wax, like other paste waxes, may tend to darken lighter patinas as they are heated by the sun. This darkening may take years to eradicate and therefore, JOHNSON Paste Wax works best on darker patinas whereby this "darkening condition" will only work to the collector's benefit.

As outdoor bronzes with dark patinas age, they tend to lighten. Placing JOHNSON Paste Wax on these lightened patinas in the heat of the day will tend to darken them once again, bringing out their deep, rich lustrous colorations. By using JOHNSON Paste Wax on a warm surface, many light blue and green colorations that may be recent developments to the patina are subdued. JOHNSON Paste Wax can be used on a cool bronze surface as well, but the restoring effects are not as dramatic on darker patinas as opposed to warm waxing. JOHNSON Paste Wax can be used on lighter patinas as well, but be aware of the possibility of patina value shifts to darker tones.

A good, **clean, flat paint brush** two to three inches in diameter is recommended for the application of paste waxes to the surfaces of outdoor bronze sculpture. The author also recommends purchasing brushes solely to be used in maintenance programs for bronze, as older used paint brushes may still contain pigment

stains trapped in the bristles from previous painting endeavors, that could possibly be transferred into the paste wax and onto the surface, giving unwanted coloration to the patinas. *"Chip" brushes are recommended as they are inexpensive and contain natural bristles in thinner rows than more expensive flat brushes.* These thinner rows of bristles are advantageous when applying wax to the surface of bronze, as they don't hold an excessive amount of wax, which could be damaging to a lighter-patinaed surface, or cause visible wax buildup on a darker one.

Various other brush shapes and sizes may be necessary in order to reach in and around tight areas of sculpted surfaces. Many of these odd shapes and sizes of brushes may also be purchased at your local hardware store, paint or art specialty store.

Most paint brushes on the market today contain metal ferrules which connect the hair bristles to the handle. These ferrules should be wrapped with masking tape or some other soft tape in order to prevent the possibility of scratching the patinaed surface with the sharp edges of these metal ferrules.

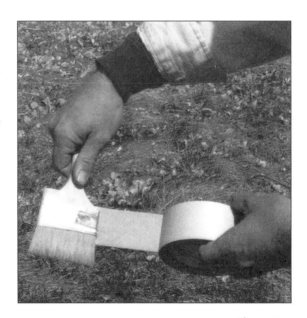

Figure 6

It is never recommended to apply paste wax with a towel or cloth to the surface of bronze sculpture placed indoors or outdoors. As paste wax is applied to the surface, it has the potential to soften and remove previous layers of wax. If a brush is used in a gentle fashion to apply paste wax to the surface of bronze, little or no protective wax undercoat removal or shifting will occur. However, when using a towel or cloth to rub the wax over a previously waxed surface, this rubbing action can easily loosen

undercoats, thus removing them from the surface and leaving the patina unprotected against the atmosphere.

Clean, dry cotton cloths are recommended for buffing or shining the wax, once it has dried on the surface of bronze. Cotton towels may also be used to help wipe down and dry the bronze sculpture after it has been thoroughly washed, prior to waxing.

Buffing the protective wax layers on bronze with a cloth is essential as the dry wax is then compressed onto the surface, giving better protection and a great lustrous shine.

Buffing wheels used in auto body shops for buffing and waxing primed car paint also work well for shining large smooth areas on monumental sculpture. Care should be taken with these machines however, because they are designed to work on hard car paint finishes and may be too abrasive or become too "hot" for polishing soft finishes on bronze sculpture. They tend to strip coloration from high points of textured surfaces rather quickly. Electric buffing wheels should be allowed to float over the patinaed surface, letting the machine do the work. *The author recommends that the collector let professional patineurs or conservationists work with this buffing machinery if needed, as they have a better understanding of the effects these machines have on a patinaed bronze surface.*

Application

Step 1. Rinse the surface of the bronze sculpture with clean running water. Pay particular attention to places in textured surfaces that collect and hold water. These places that hold water may become areas of concern in the not too distant future. Many sculptors design their artwork intended for the elements with a plan for water

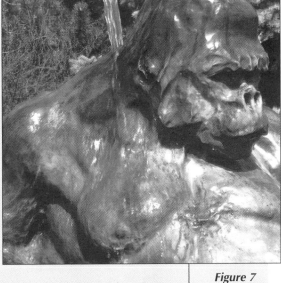

Figure 7

to run off and away from a bronze, rather than be trapped, causing eventual corrosive "rings" in the textured areas of surface. These light blue-green circles along the edges of this texture are quite natural, as this is a common reaction to water. *Figure 7*

When the design of sculpture cast in bronze does not allow for water runoff, but instead creates small reservoirs, if you will, of water and other contaminants, "weep holes" are either cleverly sculpted into or drilled through the metal's surface in

Figure 8

order to allow for drainage of these low lying areas. The water drains to the inside and then travels out through the bottom of the casting. These weep

holes are usually small and therefore, they can be easily plugged by leaves, or dirt, that may have collected in these low recesses. It is necessary therefore, to check these areas that are holding water to ensure that if they do have weep holes, they be cleared of debris. If no weep holes are found in deep crevices which could hold water, then special attention must be given to these areas during the waxing process. *Figure 8, page 55*

Figure 9

Figure 10

Step 2. Mix the recommended amount of non-ionic or neutral detergent and water in a non-metallic bucket. Begin washing the surface down using a soft non-metallic scrub brush, gently working in a circular pattern. Be sure that low lying recesses are scrubbed especially well, as this is where the first signs of corrosive attack begin. Rinse the surface of the bronze regularly to ensure that no loosened particulates have been washed into lower lying areas of the bronze.

Start washing and rinsing the surface from the top or uppermost part of the sculptured surface and work downward. *Figures 9 & 10*

Step 3. Allow the surface of the bronze sculpture to dry in the sun. Towels may be used to help soak up water remaining in low lying areas of texture. If the collector is fortunate enough to have compressed air available, the bronze surface can easily be blown free of any remaining water.

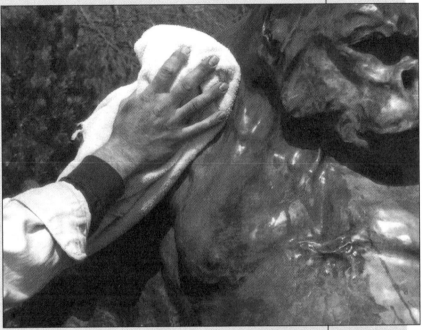

Figure 11

It is most important that the surface of bronze be very dry prior to waxing. Otherwise, water trapped under layers of wax will only discolor and fog the upper wax coatings, not to mention, disturb and possibly stain the patina below. *Figure 11*

Step 4. Waxing

A: For Dark or to Darken Patinas

Apply JOHNSON Paste Wax, using a soft ferrule-wrapped paint brush, to the surface of bronze that is at its warmest, usually in midafternoon. The surface should be quite warm to the touch. JOHNSON Paste Wax should be applied to the brush in a stroking motion by sweeping the bristles of the brush gently across the surface of the wax as not to pick up too much wax on the brush. Two or three strokes should do it. Then apply the paste wax to the surface in a sweeping fashion. The patina will darken almost immediately, hiding lighter "water stains" and other blemishes seen above or within darker patinas.

Waxing light patinas on a warm surface is not recommended as JOHNSON Paste Wax *may soak through and darken the patina for years. Figure 12*

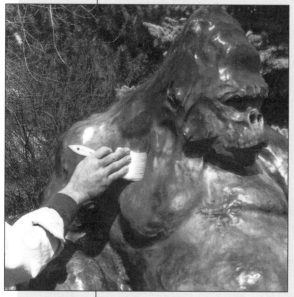

Figure 12

After applying JOHNSON Paste Wax to the surface, allow the bronze to cool, in order to allow the wax to dry and set.

Figure 13

"Hot waxing" is a term used in the art of patination which describes the application of paste waxes to a hot surface, heated most commonly by a propane torch. *This process is not recommended for the collector,* as many new patinas have not had time to age and mellow chemically. By being unfamiliar with the fine art of applying heat to a patinaed bronze surface, the collector may easily scorch and possibly destroy the existing patina. Re-patinas of large outdoor sculpture can be quite expensive; therefore, if a hot wax treatment is recommended by the sculptor or conservationist, always contract this work out to professional patineurs or conservationists who specialize in bronze sculpture. *Figure 13*

Step 4. Waxing *(continued)*

B: For Medium to Light-Colored Patinas

Apply Trewax Brand Paste Wax, using a soft fer-rule-wrapped paint brush, to the cool and preferably shaded surface of bronze, in the late afternoon or early evening. *Trewax Brand Paste Wax is a hard wax and therefore, should be applied in thin layers, as opposed to one thick coating.* Apply Trewax to the brush by laying the bristles across the surface of the paste wax and wiping back and forth in sweep-ing motions. Five to six strokes should transfer plenty of wax to the brush and eventually onto the patinaed surface. All patinas darken when first waxed. Trewax has a very fast drying time, so the time when the light patina has darkened is usually a matter of only a few minutes. *If the patina is not returning to its original coloration, then either too much wax has been placed on the surface for one single application and the excess must be gently and quickly wiped away, or the light surface of the bronze was too warm to accept wax coatings.* As soon as the patina has returned to its previous color(s), buff the wax to a glossy finish. Since Tre-wax has such a fast drying time, it is advisable to apply, let dry, and buff smaller areas of larger sur-faces, until the entire piece is covered.
Figure 12, page 58

Trewax Brand Paste Wax may be used on darker surfaces, but little or no change will be apparent if waxed cool. *Trewax is NOT recommended for hot or warm wax applications as this wax tends to cake or develop a "Mud Pack" effect on the patinaed surface.*

Step 5. After the wax has dried, use a clean, soft cotton cloth and wipe the surface in a circular pattern to compress and shine the dried wax. Be sure that recessed areas of textured surfaces are waxed and buffed as well. *Figure 14*

A clean, soft thick nylon paint brush works well to shine textured surfaces, as the bristles are able to get into hard-to-reach areas.

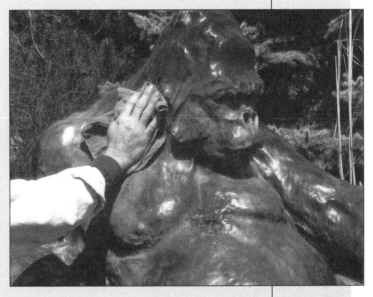

Figure 14

Step 6. Repeat Steps 4 and 5 for better protection. Also apply more wax coatings in low lying areas of the bronze surface where water tends to collect, even for short periods.

Recommended Maintenance Program

The cleaning and waxing of outdoor bronze sculpture should be done twice a year on an average. More than two treatments a year may be recommended for humid and acidic urban areas, unless patina shifting and resulting color distortion is desired. Since maintaining outdoor bronze is usually dictated by the seasons, *it is recommended in most climates within the continental United States, to clean and apply protective wax coatings to bronze sculpture on a warm dry day in late spring and early autumn.*

Never use solvents such as xylene, or turpentine to clean the surface of bronze as these will strip away not only protective wax coats, but also may possibly remove hard lacquer undercoats, and intentional pigmentation within the patina. Also, *never use car waxes on the surface of bronze,* as these waxes will cake in recessed areas and turn white when dry. Car waxes also have abrasive properties that can scratch undercoatings of wax as well as the patina.

The Care of Older Outdoor Bronze Sculpture

Older outdoor bronze statuary always shows signs of weathering, giving off some deeper hues of brown, but almost always a green streaking or an overall green and possibly black environmentally-created patina. Many of these patinas are a natural occurrence that first begins to "mellow" the original patina, either becoming darker or lighter with age, depending on the climatic conditions of the bronze setting. The original surface patina will have changed considerably since the bronze was cast. There are no signs of the original patina visible on the surface, as newly developed chemical compounds have continually washed down over the bronze, blocking out any coloration beneath. One of the great values of these older bronzes are these wonderful aged patinas. However, this streaking pattern that almost always occurs on older bronze surfaces may tend to break up any flow to a piece of bronze artwork, not to mention hiding detail due to its vertical "striping." These aged patinas are almost always a sign that these

older bronzes have not been maintained on a regular basis, let alone from generation to generation. As these bronzes continue to age in their ever increasingly corrosive atmospheres, they will eventually develop harmful compounds on their surfaces that may start to deteriorate or eat away at the surface. It is this natural development that we are concerned with, as these compounds could certainly destroy our artistic investments.

In order to keep metal treasures from further surface damage, these beautiful works of art must be maintained. There is a question of aesthetics involved in initiating a new maintenance program. Does the collector want the aged patina to remain with the same visual effect, or is a darker original coloration requested? Many collectors ponder the idea of sandblasting the older patina from the surface and then applying a new patina. *The author does not recommend the latter as a choice of color and surface restoration on many older bronzes*, because, first of all, many of these older finishes have never been sandblasted. In performing this task, flaws in the casting as well as the metal finishing may become evident, which could be costly to repair. Some older bronzes have become weak and brittle in certain areas, and sandblasting these surfaces will only make matters worse.

The only time the surface of older bronze should be blasted is when one uses a fine grit composed of walnut shells instead of sand, at very low pressure. This mild blasting treatment is to help soften the stubborn blue-green sulfate and black sulfide streaks. Although after blasting with walnut shells the colors still remain, they will not be as bright as before, and by waxing these blasted surfaces to protect them from the elements, the overall coloration will be somewhat darker. This is especially true when incorporating a "hot wax" treatment. *This treatment of walnut shell blasting and/or hot waxing, should only be carried out by an experienced professional who specializes in bronze conservation.*

Before any aesthetic decision is made, it is essential to consult with a qualified conservationist and/or art historian, for these two individuals may be able to help in the decision whether to admire the existing patina (once cleaned and sealed) or to choose a darker tonality (after warm or hot waxing). The conservationist may be able to discover signs of deterioration on the bronze's surface that passes the collector's eye unnoticed. This professional will be able to give advice concerning the best method of cleaning and sealing the surface of your older bronze casting.

Art historians may be needed to determine the artist's original intentions as far as surface coloration; i.e., the sculptor may have preferred the work to age naturally, becoming darker and greener with time, or the artist may have preferred that the work remain looking fresh and new. If this information is no longer available, then the art historian may know which patinas were in vogue during the casting of these older pieces. This may help if the collector is unsure of color choices–darker from warm waxing, or lighter from cool waxing.

In order to preserve the beauty of older bronzes for many years to come, they must be maintained on a regular basis. This maintenance should include a thorough washing and replacement of protective wax coatings.
Refer to the Application Section of this chapter, page 55.

For returning older bronzes to a darker version of their former selves, warm or hot waxing treatments may be recommended as this will darken most patinas, subduing lighter green coloration within the patina caused from sulfate developments on the bronze surface over the years.
Refer to Step 4–A in Waxing
Application before proceeding, page 58.

If older bronze surfaces are desired to retain the same weathered-looking patina finish, the surface can still be cleaned and waxed using Trewax Brand Paste Wax applied to the cool bronze surface.
Refer to Step 4–B in Waxing
Application before proceeding, page 60.

Washing the surface free of many contaminants and applying protective coats of wax will slow any further patina or bronze deterioration and help protect the surface from further contamination. In any case, it is best to maintain older bronzes, for regular maintenance may be essential to the survival of these artistic and patriotic endeavors of our past, preserving them for future generations.

Placement of Outdoor Sculpture

Sculpture of any kind becomes the focal point of almost any setting, whether placed in a private garden, in a public park, or even at busy intersections of streets and highways. For collectors of outdoor bronze art, this may be to their advantage, as these individuals will automatically notice the changes in coloration over the years, and may also be able to see when cleaning and rewaxing are required. By viewing outdoor sculpture on a regular basis, it is much easier to set up a regular maintenance program as your bronze may be a constant reminder. It is best to keep outdoor art work of any kind as visible as possible, as this is a good way to keep an eye on your investment(s). *Not only is visibility of your outdoor art work important, but locating this perfect spot for viewing away from potentially harmful surroundings may be a challenge.* Some of these potential problems are:

Irrigation sprinklers used to water lawns and flowers may, depending on minerals suspended in this water, add unwanted contaminants on the surface of bronze sculpture, from the sprinklers repeatedly splashing water across and down the statuary. Spraying water onto the bronze surface through the use of sprinklers may be quite harmful to the patina finish, because as water sprays on the metal's surface, it deposits minute amounts of minerals. These minerals may build up quickly if the surface of the metal happens to be in the spray path of a particular sprinkler on a day-to-day basis. As the amount of these mineral deposits increases, the result becomes quite noticeable, especially when the bronze surface is dry. These deposits are usually seen as crusty white, blue, and/or green layers covering areas of the bronze sculpture. *In many areas of the Southwest, this mineral buildup is usually alkaline, and therefore is usually a chalky white to beige buildup* which blocks out the patina from below. If dealt with when first noticed, this crusty deposit can be kept to a minimum with a scrub brush and a weak vinegar solution, not to mention a lot of elbow grease. *In acidic atmospheres, usually a green layer begins to develop* and can be removed by using a non-ionic detergent and water as in a regular maintenance program, only with more frequency. If both acidic or alkaline deposits are extreme, then using a mild detergent containing phosphoric acid, mixed with water can be used and scrubbed onto the surface. This

method of cleaning should only be executed by a professional in the field. In some cases, especially on newer castings, the deposits may be so thick and impossible to remove that drastic measures may need to be considered such as sandblasting the surface which could be quite damaging to the bronze, and re-patination which can be quite expensive.

Keeping bronze sculpture away from **large trees** is a good idea as well, for some trees not only weep sap, but deposit fine sprays that can come in contact with the metal's surface, leaving foreign contaminants that may be very difficult to remove. Some of these sprays and saps may not be easy to remove once they have stained the patina. Falling leaves or needles can also be a nuisance as they tend to plug up weep holes, thus causing low lying areas of the sculpted surface to retain damaging water. Leaves and water combined are also damaging as the decaying leaves will tend to make the water sitting in these trapped pockets of texture more acidic, causing patina shifting and copper by-products, that form in these areas as green rings.

Fruit from trees can also create an acidic potion when mixed with water trapped in the deep texture of an outdoor sculpture. This mixture is capable of leaving green deposits, also in the form of rings, on the bronze's surface.

If the collector happens to choose a setting for the bronze sculpture that involves close proximity to trees, then a maintenance program should be much more rigid. *Inspecting and washing the bronze surface frequently ensures that contaminants from these trees are kept to a minimum.*

Most sculptors design outdoor sculpture to be placed upon stone or concrete bases, thus keeping the artwork above **the soil**. This soil, especially in a lawn setting, may contain many foreign contaminants that can, in a very short time, be drawn "wick style" up onto the surface of the bronze. This can be easily observed as a bright green ring, two to four inches from the bottom of the sculptured surface. Continuous moisture on the surface of bronze is not healthy for the patina nor especially for the bronze itself. Bronze art pieces that are set into the soil with no protective barrier trap moisture within the bronze, not only from the ground, but from water dripping through weep holes and depositing water on the inside of the casting. This is not good for the bronze as it could tend to weaken with time, from the inside out. Disturbing

coloration could bleed through porous holes or pits on the patinaed surface that originate from the inside. Removing such blemishes could take years, especially as they would constantly be returning.

By placing sculpture at least 12 inches or 20cm above the grade of the soil beneath, bronze is allowed to breathe easier, as there are usually minute gaps between the bronze edging and the flat surface of the stone, which allow air to pass through and water to run out easily from the inside. Another reason for placing expensive bronze castings up on some sort of platform or pedestal is that it keeps the bronze out of the way of landscaping machinery. Bumpers from **lawn mowers** or the fast cutting string from **weed eaters** can also cut into and scratch the surface of bronze. Lifting the sculpture out of the paths of these machines would greatly protect the bronze surface.

Many collectors innocently place bronze sculpture within a **swimming pool** setting. If this is done, please be advised of the hazardous elements that may be exposed to the surface of the bronze from contaminants given off by chemicals released from the pool's water. Chlorine, added to pool water, is given off at the surface of the water in the form of chlorine gases. These gases may, in a short time, come in contact with the surface of these bronzes, depositing contaminants that result in the formation of copper chlorides, which are quite corrosive to the surface of bronze. These chloride deposits are usually seen as green spots or crusty-green residue, wherever this chlorinated pool water has come in contact with the bronze's surface.

If unwanted contamination is the goal of the collector, then it is advisable to keep bronze as far from the surface of the pool water as possible, as well as away from splash and continuous fume exposure. *Bronze sculpture is not recommended to be incorporated into any sort of fountain setting involving the use of pool water, as this direct, continuous contact with the chlorinated water may be very damaging to the surface and especially the bronze patina.* Always ensure that bronzes chosen for a pool setting be well-maintained and frequently checked for signs of surface contamination, due to new color development, that usually appears as green or blue-green spotting.

The question that the collector of outdoor bronze statuary must ask when placing sculpture is "What is its **accessibility** for maintenance?" By placing bronze far away from running water, or

placing the bronze high on a stone pedestal, or isolated–out in the middle of a large pond–can all cause problems when formulating a maintenance program. Placing bronze sculpture in these settings usually requires some sort of financial budgeting for renting or purchasing such things as scaffolding in order to reach bronzes placed in or on high locations, and boats, in order to access bronzes located in the middle of ponds or lakes. So if possible, always consider easy accessibility to the surface, as this will affect how well and therefore, how safe bronze sculpture is from its sometimes unfriendly surroundings.

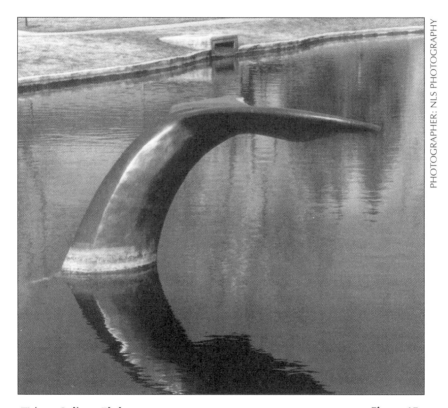

PHOTOGRAPHER: NLS PHOTOGRAPHY

Title: **Salient Fluke** *Figure 15*
Artist: Phillip McTaggart & Friends

Figure 15 shows contaminants in fountain water that have been deposited on the lower section of this piece where the water is in continuous contact with the bronze surface.

Bronze Fountains

Whether bronze sculpture is incorporated within a water setting or is actively incorporated into the water's flow, as with water running down the bronze's surface or spraying up on the casting from below, special consideration must be taken into account when caring for fountains containing this metal. *Water is the major transporter of foreign contaminants to the surface of bronze, and therefore has the ability to do more damage to a bronze patina and the surface itself, than almost anything else in nature.* Since water always creates, most commonly, unwanted changes in the original patina and casting surface sooner or later, these changes must be dealt with, and in most cases, the sooner the better.

Collectors who purchase bronze fountains and expect no change in the patina or surface during or after use, are going to be quite surprised very quickly, especially people living in the southwestern United States. The water, for the most part, is high in mineral salts throughout this entire region. These mineral salts are commonly seen in the form of white or beige crusty layers on the surface that tend to matte out the patina beneath, eventually depositing layer upon layer of this thick hard crust. When this water runs down the surface of bronze, it tends to channel or make light-colored streaks that then build layer upon layer, as the water continues to run down the surface. The beginnings of these mineral salt deposits on the surface may be hard to see, especially when the bronze is wet. As the bronze surface dries, however, these unwanted deposits tend to show.

Bronze fountains in use in the Southwest demand very rigid maintenance programs and even then, the collector may be fighting a losing battle. Since the problem is mainly the water, even suggested short term cures may be expensive. Since many fountains are smaller for the more domestic setting, they may not hold more than 5 to 10 gallons of water. By using filtered bottled water or distilled water instead of the local drinking water, the problem of surface change and crusty buildup is slowed slightly. There is one major drawback to this plan however, and that is cascading water in a fountain evaporates quickly making water replacement necessary and often. This becomes quite expensive, and unless the collector has a cache of filtered water, this may be impractical.

One of the safest ways to deal with water containing high mineral salts is to contact the local water department for recommendations as to methods of chemically treating the local tap water to balance the water's pH, thus slowing this crusty buildup for some time. Local swimming pool companies are another source of information on treating the local water. *However, please be advised that there are major drawbacks to adding chemical compounds to high pH water, as many compounds used to balance a high pH level are acidic.* By making the balance more acidic, this may cause a greening of the surface. Other products used by these companies contain chemical compounds that may severely attack the patina and bronze surface itself, causing possible surface deterioration. Therefore, if this method is chosen, beware that color changes will continue on the bronze's surface, but possibly in a different direction.

As mentioned, bronze fountains located in water that is acidic, will tend to channel, or streak, with more of a green to blue-green coloration. Leaves, twigs and other organic refuse that fall into the water of an outdoor fountain also add to the acidity of the water. One soon realizes that no matter how carefully you maintain your bronze fountain, the battle to stop your bronze from turning green will eventually be lost.

This "greening" of a fountain is the natural result of the bronze alloy continually exposed to such an extremely humid atmosphere. This is one reason why most bronze fountains are finished with a green patina, or have green somewhere within the surface coloration. If a bronze fountain does not have green hues somewhere within the patina, while in use it soon will have. This greening is part of what gives fountains cast in bronze their aesthetic value.

One other way that bronze fountains become contaminated is when contending with plant life such as algae, growing within the basin of the fountain. This plant can take over a fountain or pond in a very short time during the summer months in North America. Chemical compounds added to the water, used to help control the algae, may also be another source of surface greening. Many of these chemical mixtures used for the control of algae contain copper sulfate or copper chloride, which is what is seen on older non-maintained bronzes in large urban areas.

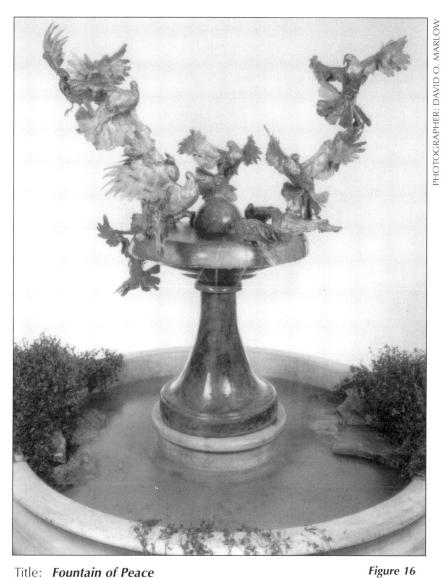

PHOTOGRAPHER: DAVID O. MARLOW

Title: ***Fountain of Peace***
Artist: Sandy Scott

Figure 16

*Figure 16 is an example of a well-maintained fountain.
Courtesy of Brookgreen Gardens, South Carolina*

Therefore, if color changes in the patina and bronze surface are anticipated by the collector, then a fountain may bring great joy. Although fountains are a lot of work; keeping the algae growth contained, maintaining the freshness of the water by keeping debris out of the basin area, keeping return filters cleared, etc., they are usually worth the effort. Bronze fountains tend to take on a character of their own as they age, and color patterns develop, due to its humid atmospheric condition.

The maintenance programs designed for fountains are strict and frequent, depending on climatic conditions. Although their surfaces should be washed with a non-ionic detergent, rinsed, and then rewaxed occasionally, this task would have to be performed while the water is turned off and the basin is drained. *The type of non-ionic detergent is very important in that it should have a desudser added to the wash water mixture before use in a fountain setting.* If a defoamer is not used, the collector's bronze fountain could soon turn into a bronze bubble bath when the water is turned back on. *Three to four coats of wax are recommended for the protection of many bronze surfaces incorporated in a fountain setting.*

Although these coats won't keep the bronze surface from turning colors, it will help in the protection from harmful elements found within the fountain water, and retard any surface deterioration. After all, with bronze fountains, the original patina is not as important as the bronze when it comes to protection, because the surface patina is short-lived; whereas, the bronze itself will remain in this humid environment for many years to come.

Fountains in general are usually one of the more complicated pieces to maintain, especially in an open environment. The addition of this copper alloy, bronze, to the fountain environment is even more challenging. If this challenge is met successfully, however, bronze fountains with their ever-changing appearances, will bring joy to the avid collector for years to come.

Credits

Chapter 3

Figures 1 through 5
 Artist: Valentin Okorokov
 Title: **Persephone**
 Photography: Mel Schockner

Chapter 4

Figure 6
 Photography: NLS Photography

Figures 7 through 12
 Artist: Sherry Salari Sander
 Title: **Gorilla**
 Photography: NLS Photography

Figure 13
 Photography: Mel Schockner

Figure 14
 Artist: Sherry Salari Sander
 Title: **Gorilla**
 Photography: NLS Photography

Figure 15
 Artist: Phillip McTaggart and Friends
 Title: **Salient Fluke**
 Photography: NLS Photography

Figure 16
 Artist: Sandy Scott
 Title: **Fountain of Peace**
 Photography: David O. Marlow

Chapter 3 *Application* demonstration model:

Photography: Sandra Bierman

Persephone

Artist: Valentin Okorokov

Chapter 4 *Application* demonstration model:

Photography: Bill Carpenter

Gorilla
Artist: Sherry Salari Sander

Cover Photo: Detail of "Girl With Ribbons"

Girl With Ribbons
Artist: Glenna Goodacre

Collection of the City of Loveland, Colorado
Benson Park Sculpture Garden

Salient Fluke
Artist: Phillip McTaggart and Friends

Notes

Recommended Reading

Guide to the Maintenance of Outdoor Sculpture
by Virginia N. Naudé and Glenn Wharton,
American Institute for Conservation of Historic
and Artistic Works (Washington, DC) 1995

Sculptural Monuments in an Outdoor Environment
A conference held at the Pennsylvania Academy
of the Fine Arts, Edited by Virginia Norton
Naudé (Philadelphia, PA) 1985